Drawing Landsca

Ronald Swanwick

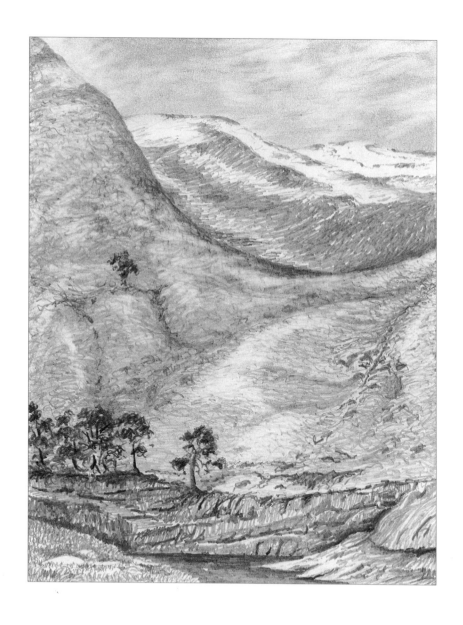

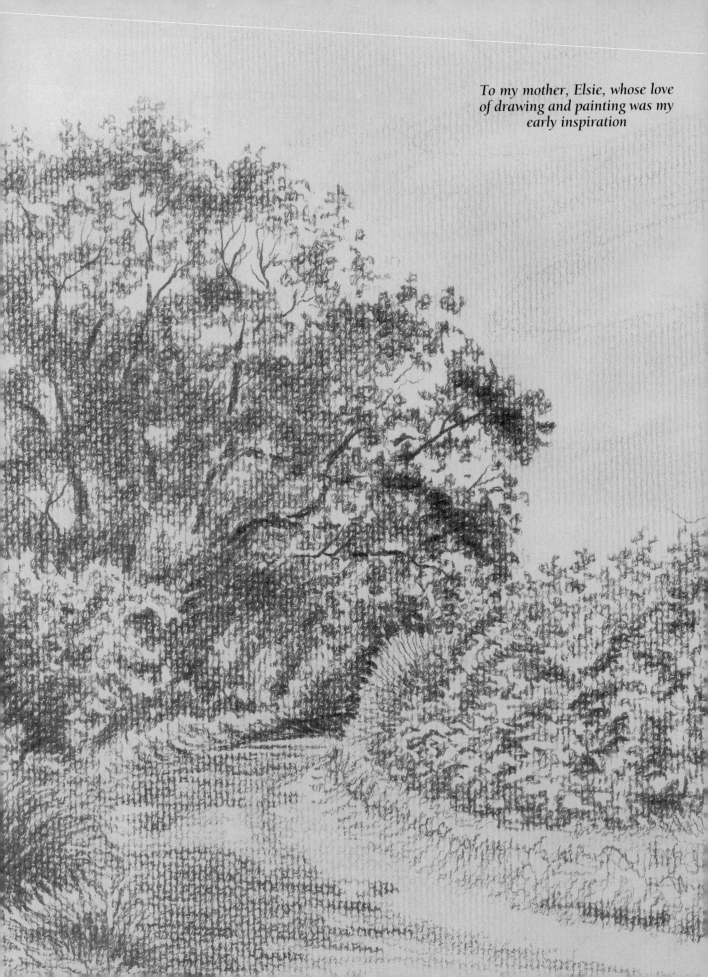

To my mother, Elsie, whose love of drawing and painting was my early inspiration

Drawing Landscapes

RONALD SWANWICK

SEARCH PRESS

First published in Great Britain 2001

Search Press Limited
Wellwood, North Farm Road,
Tunbridge Wells, Kent TN2 3DR

Reprinted 2002, 2003, 2004

ISBN 0 85532 846 0

The publishers and author can accept no responsibility for any consequences arising from the information, advice or instructions given in this publication.

Suppliers
If you have difficulty in obtaining any of the materials and equipment mentioned in this book, please visit the Search Press website at **www.searchpress.com** for details of suppliers.

Alternatively, you can write to the publishers at the address above for a current list of stockists, including firms which operate a mail-order service.

Publishers' note
All the step-by-step photographs in this book feature the author, Ronald Swanwick, demonstrating how to draw landscapes. No models have been used.

Printed in Spain by Elkar S. Coop. Bilbao 48012

Page 1
Highland Glen
HB pencil on 90lb cartridge paper
Time taken: 80 minutes

Pages 2-3
Country Lane
4B pencil on pastel paper
Time taken: 2 hours

Page 5
Seascape
Soft chisel pencil on rough watercolour paper
Time taken: 40 minutes

Pages 6-7
Tudor cottages, Welsh borders
HB pencil on cartridge paper
Time taken: 4 hours

Contents

Introduction 6

Materials 8

Composition 10

Perspective 14

Marks and tonal values 18

Sunshine and shadows 22

Working with photography 23

Skies 24

Old Farm Building 28
Step-by-step demonstration

Trees 32

Winter Woodland 34
Step-by-step demonstration

Water 40

Using photographs 44

People and animals 46

Index 48

Introduction

The foundation for all artistic endeavour is, without doubt, drawing. I first developed a passion for drawing at the age of eleven, and in the forty years which have passed since it has never diminished. I paint in and teach oils, acrylics and watercolour and believe my best works come from my drawings and sketches. During the process of drawing or sketching you observe and soak up the atmosphere, and can sort out the composition and tonal values which are the most important parts of a painting. Colour, which is subjective, can be formulated in the studio. However, photographs can be extremely useful, especially when you are short of time.

In this book I will share some of my approaches to drawing landscapes. These may vary according to time constraints, the subject matter, weather conditions or whether I see the work as an end in itself or a preparation for a later painting. My personal definition of drawing is a work brought to completion with accurate and careful note of all the textural and tonal values, whereas a sketch is as succinct as possible and contains my own form of shorthand to prompt my memory.

You will see that I have recorded the time taken for many of the finished pictures in this book, because I believe speed is a vital ingredient in a good drawing or sketch. A sense of urgency adds fluency to your marks which will lead to a much more pleasing finish. I hope the following pages will inspire you to go out and use a pencil at least as often as a brush.

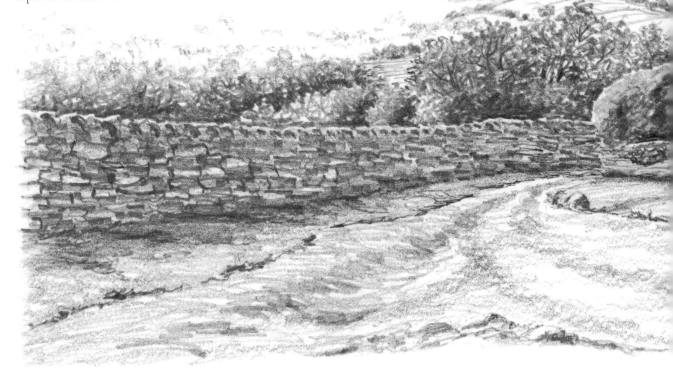

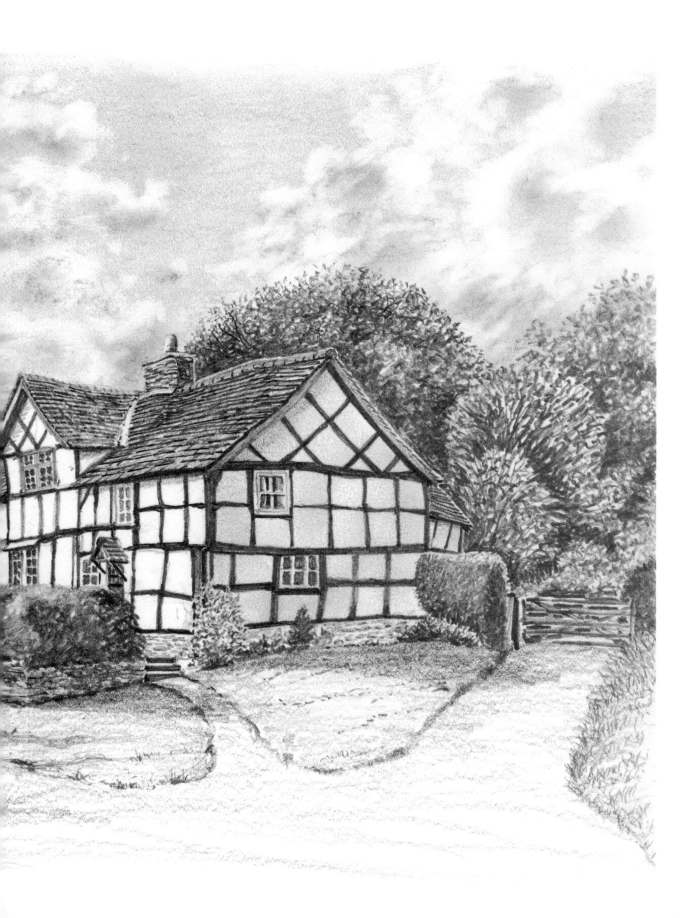

Materials

Pencils

Always choose good-quality pencils with a cedarwood case. Cedar is easy to sharpen and good-quality graphite in a pencil means no annoying gritty bits. For most illustrative drawings, I prefer an HB pencil. If I am making quick, bold drawings or sketches I will choose a softer pencil: 2B; 4B or 6B.

Water soluble pencils

These are available in various grades (2B, 4B, 6B etc.), or they may be described as light, medium or dark wash. They are excellent for producing smooth, grey wash effects.

Chisel pencil

This gives you a mark peculiar to itself; experiment to produce a variety of different effects.

Graphite stick

Ordinary pencils are made from a mix of clay and graphite. Pure graphite sticks are available in grades from soft to hard (I prefer the soft ones) and give a pleasant waxy, shiny finish. They are big, chunky and very bold, so are great for working in larger formats.

Charcoal

I always use the best-quality willow charcoal, which is available in various thicknesses.

Chalk

There is no need to buy any special chalk - ordinary blackboard chalk is fine.

Eraser

I prefer a putty eraser because it is clean to use, absorbs graphite and can be moulded into any shape. Plastic erasers can smear or disintegrate, leaving unwanted bits all over your drawing.

Craft knife

I always use a craft knife for sharpening pencils because it is portable, light and much safer to use than a scalpel or a handyman's retractable knife. It is also much sharper than a penknife, so it allows you to put a fine point on your pencil without the risk of breaking it.

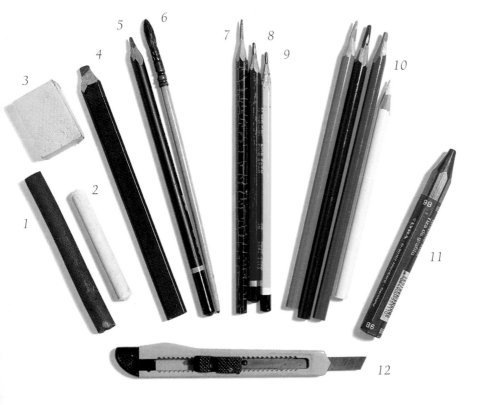

1 Willow charcoal
2 Chalk
3 Putty eraser
4 Chisel pencil
5 Water-soluble graphite pencil
6 Small brush
7 HB pencil
8 4B pencil
9 6B pencil
10 Water-soluble pencils
11 Graphite stick
12 Craft knife

Paper

Have lots of different papers and experiment to find which you prefer. There is no reason why you should not use watercolour paper for drawing! Try out any paper you come across; you will find that the same composition drawn on different papers can lead to strikingly different results.

Sketch book

I generally prefer to use an A5 tape-bound sketch book, but a wide variety of pads and books is available, in many different sizes and bindings. Carry one with you wherever you go – and use it!

Drawing board

Hardboard is lightweight and stable. I use an A2-size piece as a drawing board (not shown).

Masking tape

This is useful for fixing paper to your drawing board. As an alternative, I sometimes fix the paper to my board with large, spring-jaw clips (not shown).

Portable chair

I often use a portable chair (not shown) in the field, but there is no doubt that this constrains me to a small format. If you prefer to be loose and expansive in your movements, try standing at an easel.

Easel

I prefer a portable easel made of metal because I find them more stable than the lightweight wooden ones (not shown).

> **Note** *To protect your paper against the textural value of the backing board, put an extra piece under the one you are working on.*

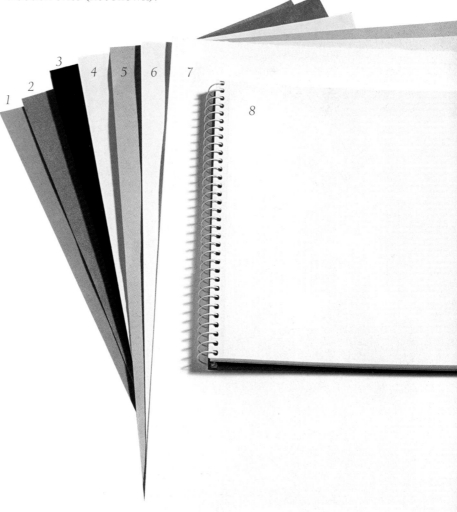

1&2 Pastel paper

3 Black mount board

4 Coated board 160 gsm

5 Sugar paper

6 Cartridge paper 130 gsm

7 Watercolour paper 300 gsm

8 Sketch book

Composition

Composition is a core ingredient in the creation of every successful drawing or painting. If you fail to achieve a good composition, your picture will be less successful even if your technique is superb.

If you are taking photographs to work from (see page 23 and 44), think about composition by asking yourself what story you want to tell. Always take several shots from a range of angles. Remember that your camera will only take an average light reading, so take close-ups of any dark areas, especially on very sunny days. If you particularly want strong shadows in your composition, take photographs either early in the morning or in the evening when the sun is low. This will give your shots far more contrast, which is especially important for snow scenes.

Old cart

In the garden of my studio is a rather dilapidated horse-drawn cart. The examples show how I used different views of the cart and its surroundings to plan my final drawing.

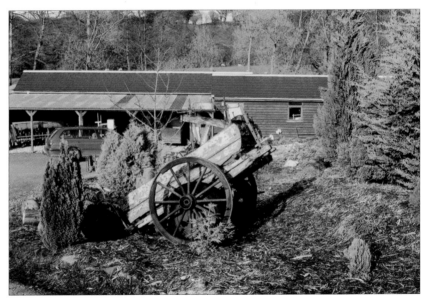

This is the first view of the cart as you come down the drive. The composition from this viewpoint has little to commend it; the cart is in the middle of the frame and the roof line of the buildings chops the picture neatly in two. Despite the fact that the cart is the intended subject, I find that my eye is inexorably drawn to the red car in the background.

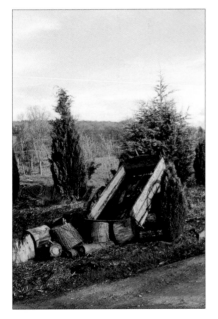

This shot in portrait format and at a different angle gives a better backdrop, but the composition is a little awkward, even though there is an interesting shadow of the wheel on the side of the cart. The two spaces on either side of the conifer on the left makes the arrangement feel a little regimented. Making the conifer bigger and moving it to the left is one possibility, but I would still look for a better option.

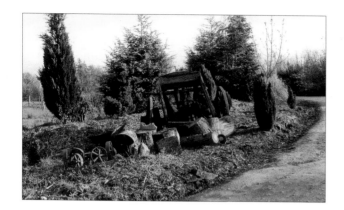

For this shot, I have moved further to the left and changed to landscape format. I much prefer the curve of the edge of the drive, but the head-on view of the cart is not very attractive. The way in which the lines of the cart coincide with the slight lean of the trees gives the composition a definite list to the left.

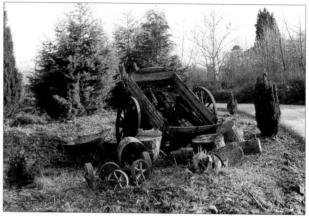

I have finally settled for a shot taken from a little further to the left and slightly nearer to the cart. Although the cart is more or less in the middle, I feel that, with a few slight modifications, this will produce the best composition.

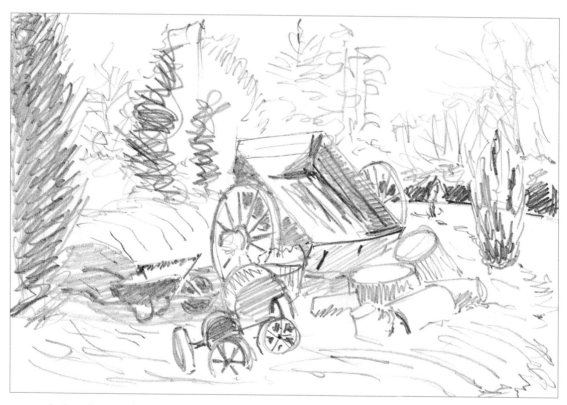

If you compare the last photograph to this final planning sketch, you will see that the major modification is the large, dark shape of the conifer on the left. The conifer from the centre of the photograph has moved slightly to the right, which increases the space between the conifers and creates a greater sense of depth. The dark conifer in the top right background of the photograph has been eliminated, further accentuating the feeling of space. I have also paid attention to the composition of the shadows, as these play a very important part in the creation of a successful composition.

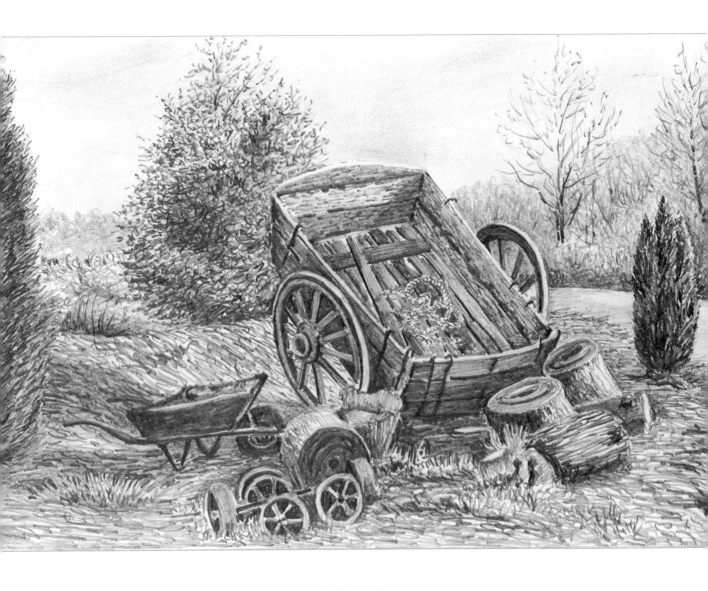

The finished drawing

If you compare the finished drawing to the plan on the previous page, you will see that there is a further modification: I have matched the left wheel to the right to make the appear to be attached correctly to the cart. In fact, the wheels are simply lying against it until I find the time to take off the modern rubber wheels and fix the original wooden ones back on.

An important point to remember when planning a composition is that you are making a drawing or painting for its own sake: you do not have to record exactly what is there. Feel free to move things and experiment with planning sketches.

Time taken: 2 hours

Cider press

This rare example of a travelling cider press is also in my studio garden. I hope to restore it one day, but even in its dilapidated state it is an interesting subject.

The press is in a corner of the garden which is being used to store building materials. It is impossible to take a photograph which will make a good composition, so some ingenuity is required to create a pleasing picture. The sketches below show how I have manoeuvred the scale and position of the press, and removed undesirable items from the view. All three plans are acceptable, but I prefer plan C because it feels more comfortable and seems to have a little more breathing space.

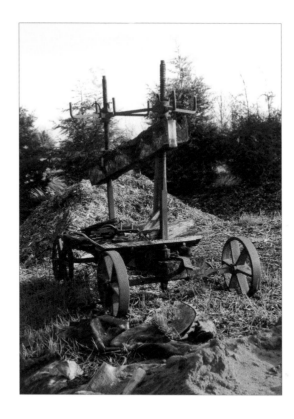

The photograph. First I want to deal with what I call the 'unfortunate coincidences': the top of the trees is in line with the top of the press, and the top of the pile of wood chippings is in line with the beam of the press.

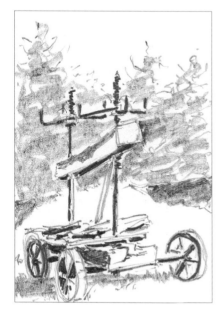

Plan A shows that by raising the height of the trees I am able to create a strong contrast with the winding gear, and give the impression that the press is bathed in light.

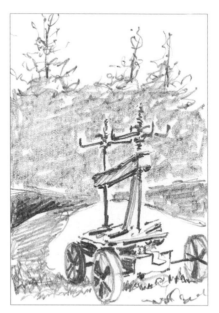

In plan B, the press has been reduced in size and moved to the right. The height of the pile of chippings has been lowered, which presents a less-confusing conjunction of lines.

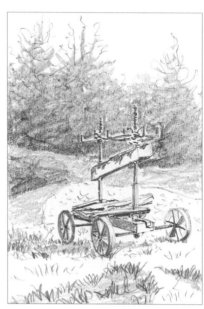

Plan C is the option I prefer. I like this composition because it allows me to use strong contrasts of light against the conifers, giving the effect of 'lifting' the machine off the background.

Perspective

Most people who are learning to draw and paint find perspective one of the most difficult aspects to master – but it is imperative that you do. Never make the mistake of thinking you can manage without accurate perspective. This is true even of artists who work impressionistically. The work of Monet is a perfect example: his landscapes with buildings are perfectly accurate. Even in paintings like his studies of waterlilies, which look as though he virtually threw the paint at the canvas, the perspective is faultless. This is one of the main reasons for the feeling of depth which results from looking at one of these huge canvases.

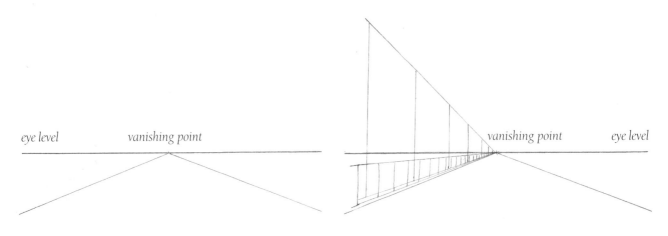

This view is from the middle of the road. The sides of the road are both parallel and horizontal, so they go to the same vanishing point (vanishing point).

All the horizontal lines on the telegraph poles and the fence posts are parallel both to each other and the road, so they all go to the same vanishing point.

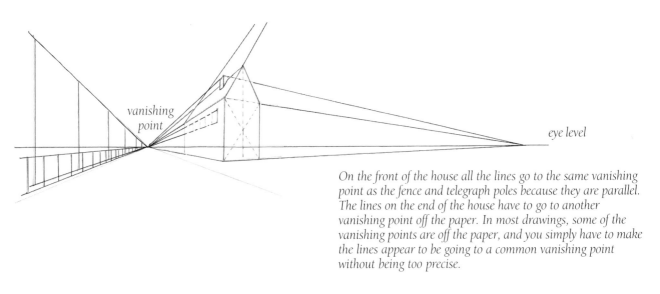

On the front of the house all the lines go to the same vanishing point as the fence and telegraph poles because they are parallel. The lines on the end of the house have to go to another vanishing point off the paper. In most drawings, some of the vanishing points are off the paper, and you simply have to make the lines appear to be going to a common vanishing point without being too precise.

For this example I was straddling the kerb, which made the edge of the kerb appear as a vertical line on the page. The angle of the roof line reflects the width of the street: if you were in the narrow streets of a small fishing village, the angles would be very acute. You can check the angle against your pencil by holding it at arm's length either horizontally or vertically.

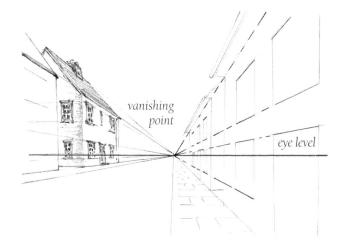

This outline drawing could be used for a brick, stone or timber-framed building. I make sure I have the proportions and perspective correct before putting in any detail. Note the relationship between the far gable end and all the lines across the front of the building: it is easy to make mistakes if you only consider the elements separately. The tops of chimney stacks often cause mistakes: make sure the angle for the perspective is correct. Note also the gradient of the lane, which means that the lines go to a different vanishing point.

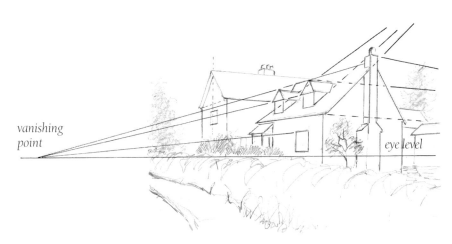

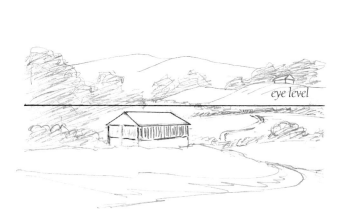

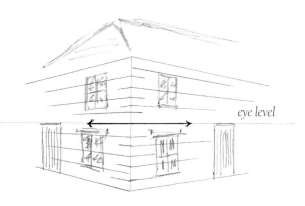

When buildings in a landscape are quite small, the angles of perspective are very subtle – but they are still there! Make sure you still check for your eye level and find the perspective.

To find your eye level, hold a pencil horizontally at arm's length, level with your eyes. Close one eye and look past your pencil to see where the top edge of the pencil crosses the building. When using photographs, place the pencil horizontally on the photograph and slide it up or down across the nearest corner of the building. Your eye level is where the lines on each side of a corner form a horizontal line straight across the photograph.

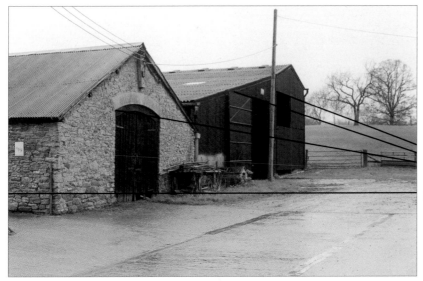

These farm buildings are on a sloping site, so the rising angle of the yard will not vanish to the same point as the lines on the building, and the two elements should be treated separately.

eye level

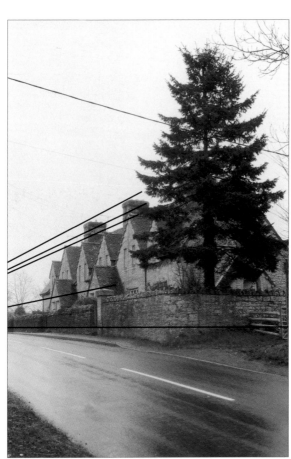

eye level

eye level

In this example, the eye level is almost at the bottom of the wall at the nearest corner, so the lines of perspective on the building all descend. Take care not to confuse the line of the kerb with the perspective of the building: the gradient of the road means it has a different vanishing point.

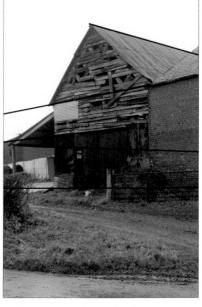

eye level

In this example the eye level is at the bottom of the building, so all the lines of perspective descend, away from you, to a vanishing point off the photograph to the left. Notice also the steep descent of the roof, which goes to the same vanishing point on the right as the underside of the lean-to roof.

This photograph shows how your eye level can be found where the lines on both sides of a corner are horizontal. One vanishing point is on the right of the photograph, just above the gap in the wall, while another is way off the photograph to the left.

eye level

In this photograph, the lines of perspective are very subtle but it is still important that you angle them correctly. Again, the road is sloping so its vanishing point is not on your eye level.

Marks and tonal values

Drawing is simply making marks on paper, with whatever implement you choose. There are twenty-six letters in the alphabet of language but in the alphabet of drawing there are only four: dots, lines, squiggles and washes. The mark you make and the tonal value you ascribe to it is the way to describe the texture of a surface. Putting together these marks and tones allows you to build up a surface to look like anything you wish.

The simple answer when asked how to draw anything is: 'Draw in the dark bits and leave out the light bits!' Another way to describe this is to see things as positive and negative, and draw only the positive. Remember that, in nature, lines do not exist: they were invented by man to draw diagrams. When two surfaces meet, the tonal and textural value may change but that no line separates the two. You should never draw lines round objects, then fill them in.

Think of your composition as a pattern or jigsaw and try to build up the different parts which make up the whole.

Sharpening pencils

RIGHT: with your thumb on the blade to keep it steady, and moving the pencil back.

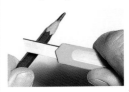

WRONG: holding both the pencil and the knife too far down.

The drawing alphabet

Dots

Dots are best in very detailed drawings e.g. for gravel, or mixed with squiggles for details of stone or brickwork.

Lines

Linear marks are used for hair, fur and feathers as well as for architecture.

Squiggles

Squiggly textural marks are most often used to describe foliage.

Washes

A linear wash is ideal for most surfaces on buildings, as well as many other smooth surfaces.

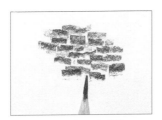

A patchy wash with different tonal values. Applications include walls; roofs with different tones of tile; fields.

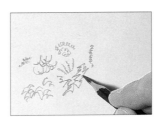

When using a squiggly wash the tightness of the curls can be varied; use the same mark but different scales.

Tonal value

When you draw, there are three questions which you should be asking yourself. One is which mark to use, and this is answered by choosing a mark or a combination of marks from the four in the drawing alphabet. Another is where you should put the mark, and to answer this question you make a plan of your composition. Then there is the question about how hard to press, which is the tonal value question.

Tonal value can be explained as the degree of darkness required for the mark. If you propose that there are ten degrees of tonal value, you simply have to compare one area of your subject with another on a scale of one to ten.

To plan your final drawing, it is a good idea to do an outline sketch, then a tonal plan, then complete the picture – see the demonstration which begins on page 33.

> *Note when you press on hard to make a very dark tone, keep your pencil at a 90° angle to the paper, which will reduce the risk of breaking the point.*

Think of white paper as zero and black as ten. Between these extremes you will find nine degrees of tonal value

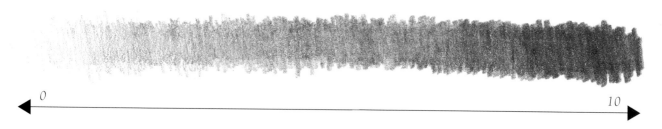

0 10

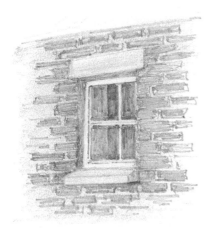

Example A.

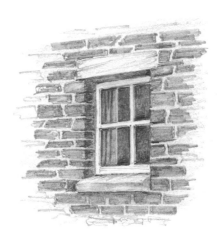

Example B.

The effect of contrast

A question I am often asked when I am teaching is what should be erased to make a dull, grey drawing look brighter. The answer is nothing: what you should do is put more tone into the dark areas. This will create a greater contrast between light and dark areas, thus making the image appear brighter. In each of these examples, the window bars have exactly the same tonal value, but they look brighter in example B because the contrast is greater.

Making marks

Always make your planning sketch lines with marks which are sympathetic to the subject. A plan of trees works best with faint squiggles, and stones on a beach can be represented with dots and dashes. The following examples should help you to develop these ideas.

Foliage

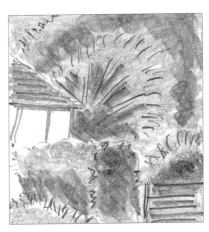

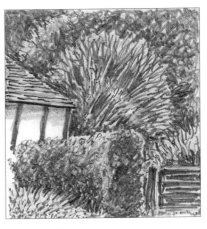

1. With an HB pencil and using marks which will 'disappear', plan the drawing.

2. Add light and dark washes over the whole of your drawing to build up the tones.

3. Add dark squiggles for the hedge, linear marks for the tree behind it, and larger squiggles for the more distant tree.

Stone wall

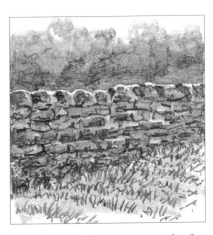

1. Lay in the first light washes, using a linear wash for the wall and a squiggly wash for the trees in the background.

2. Put in linear marks to denote the gaps between the stones. Darken the trees, leaving a white highlight along the wall so it will stand out from the background.

3. Finish with stronger marks for some of the gaps, and shadow areas on some of the stones. Note the effect of the highlight along the top of the wall.

Beach

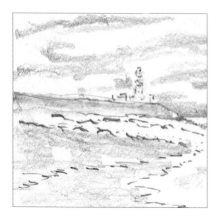 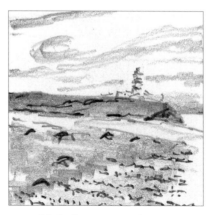 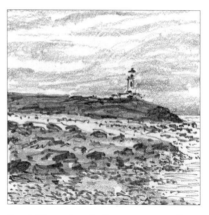

1. Make a plan using pale washes and a few linear marks.

2. Add darker tones where appropriate, and put in the main marks to give the lie of the land.

3. Adjust the darker tones and finish with dots and shadows.

Roof tiles

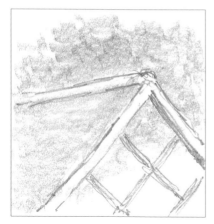 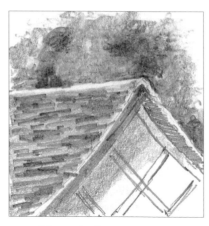 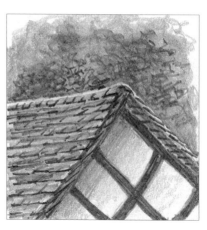

1. Draw in the outline of the roof and lay in light washes.

2. Add patchy linear marks to the roof and shadow under the far side of the roof.

3. Finish with dark linear marks for the joints in the ridge tiles and roof tiles. Darken the beams and build up the background foliage.

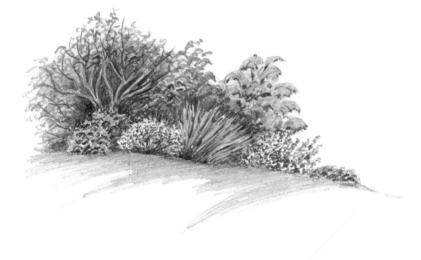

In this drawing of a clump of different types of foliage, the effect of highlights on the foreground plants is produced by the shadows in the tall plants behind them.

Sunshine and shadows

The shadow areas in a picture are very important, and my maxim is: don't be afraid of the dark. The only way to achieve the effect of light in your drawing is to put on shadows which are sufficiently dark.

The main point to remember about cast shadows is that the textures in the shadow area must be the same as in the light area: it is only the tonal value which is darker in the shadow. Leaving out white spaces will give your drawing extra sparkle – as long as they are small! If they are too big, they will simply look as though you have missed bits out. The ivy leaves on the trees in the drawing below are an example of how effective this technique can be if used carefully.

Note *always put in the shadow areas before adding any texture.*

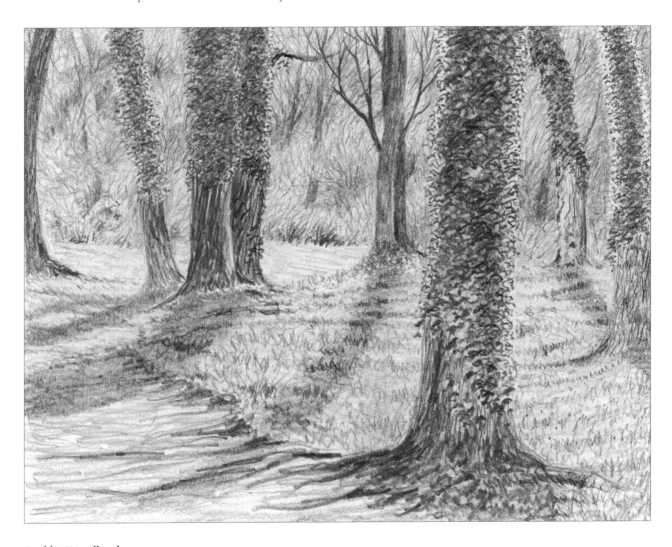

Backlit Woodland
Time taken: 3½ hours

Working with photography

When taking photographs on a sunny day, the lightest and darkest areas will inevitably suffer from under- and over-exposure. This photograph of a seed drill in an open shelter has not picked up detail at the back of the shelter, which you would be able to see. The stones appear far brighter than they would to the eye.

There are different ways to overcome this problem. If you have a manual camera, you can take extra shots at least two stops either side of the correct exposure. For both automatic and manual cameras, it is a good idea to move in closer and take shots of the interior with the correct exposures. This will help you to decipher the details when you plan your drawing.

Things are slightly more difficult if you are using a photograph which does not show enough detail, but which you did not take yourself. In this case, the best solution is to fill in what you think should be there. You cannot produce a successful drawing by filling in 'black holes' without any suggestion of texture.

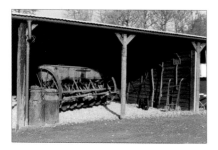

Under-exposed

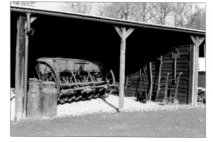

Correct exposure

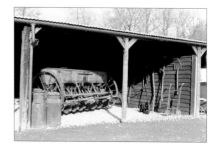

Over-exposed

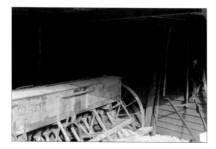

Detail of interior

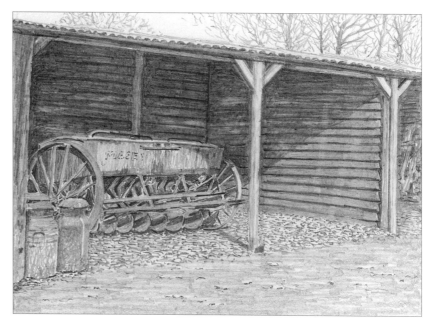

The finished drawing

Massey Ferguson seed drill c.1959

Time taken: 3 hours

Skies

The sky will set the mood or atmosphere of any picture. In most drawings of landscape, I suggest that you should include some clouds. A simple way to do this is to use a putty eraser as a drawing implement. First, put on a wash over the whole surface using a soft pencil, because these will smudge more easily. Then rub the pencil in well to eliminate any lines, using a circular movement. Crossing your fingers (see photograph A, right) will help to give extra pressure, but this is not obligatory! When you want a pale sky, use a soft pencil but do not press too hard.

Take a putty eraser and knead it into the shape you want, then use it to remove the pencil so that the white paper behind is revealed in the shape of the clouds (see photograph B, right).

Photograph A

Photograph B

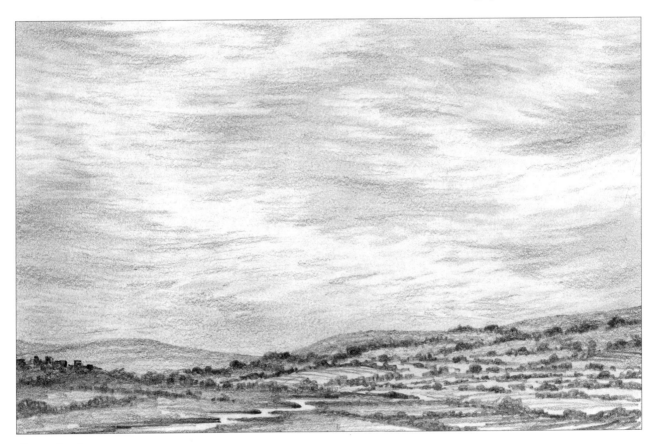

Cirrus clouds

I have made this picture mostly sky, which always gives a tremendous feeling of space. The high, cirrus clouds with their descending pattern enhance the sense of depth. The sky is simply a wash of grey, with the pattern of clouds lifted out using a putty eraser.

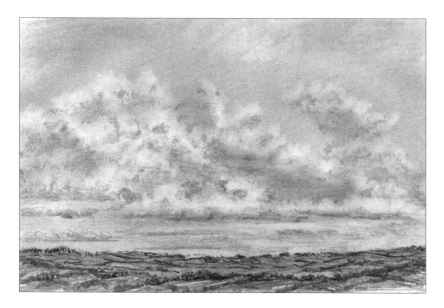

Cumulus clouds

Note the fact that clouds like these are flat-bottomed, and the top of the clouds furthest away are chopped off by the bottom of the nearer cloud. Done well, this gives a good sense of distance in your landscape.

For the nearer cloud, I smudged in a grey wash all over, then lifted out the clouds with a putty eraser and added the shadows to give them some shape.

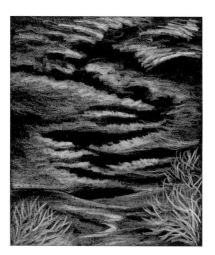

Moonlight sky

This drawing is with a white pencil on a piece of black mount board. Try experimenting with different dark colours of board. You might also try using a limited range of sepia or earth colours for a night scene, which I find works very well.

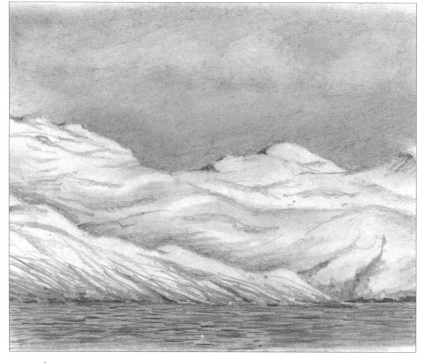

Grey sky over mountains

If you use a good-quality coated board for a snow scene, you can put in a grey wash all over the paper and lift out all the white areas with a putty eraser. Note that, if you want the sun to shine, you must create a very sharp edge against the sky.

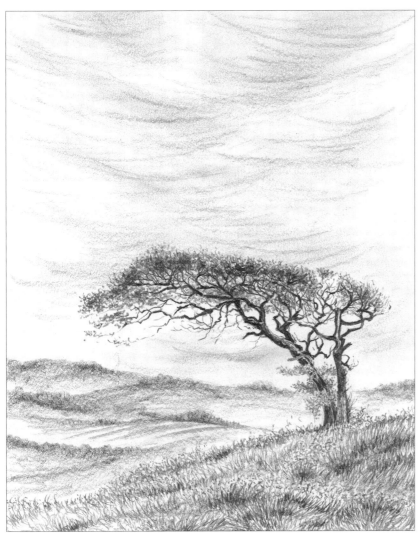

Windy sky

I came across this wind-blasted tree beside a main road on a sunny day. In this composition in HB pencil on cartridge paper, I have chosen to set it in an open field, and have given the sky a windy look to complete the story.

Time taken: 2 hours

Hillside Farm

This drawing is in coloured pencil on pastel paper, a technique which gives a very soft finish. It is difficult to produce strong contrasts, particularly as I do not use black. I would use the same technique in shades of grey for soft winter, or in shades of reds and golds for autumn, but it is important to keep it subtle and not to use too many colours.

Time taken: 3 hours

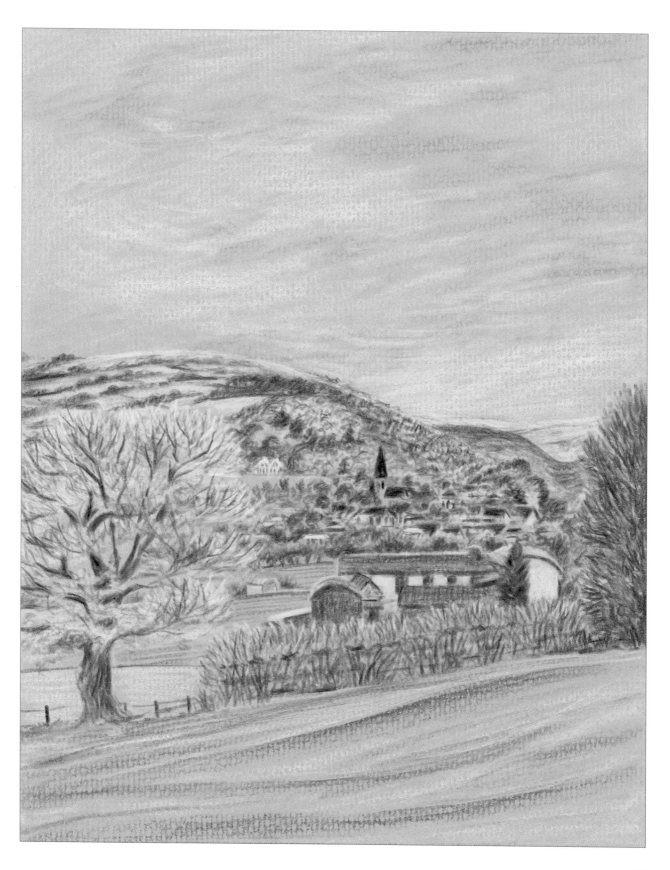

Old Farm Building

This derelict farm building belongs to my local Wildlife Trust, which had put up a temporary shelter to protect it. I took lots of photographs and used them to plan my final composition. In the final drawing, each stone has been completed with an individual stroke of the pencil. The process may seem painstaking at first, but with practice you can build up a rhythm and make progress quite rapidly.

For this drawing, I used an HB pencil and an A4-size piece of good-quality cartridge paper.

Note If you begin in the top corner of your picture and work to the opposite bottom corner, it helps to avoid smudging your work. I am right-handed, so I work from the top left to the bottom right corner.

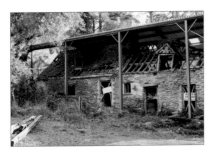
Close-up of roof detail

Detail of the wall and the woodpile

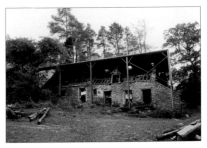
The building and its surrounding area

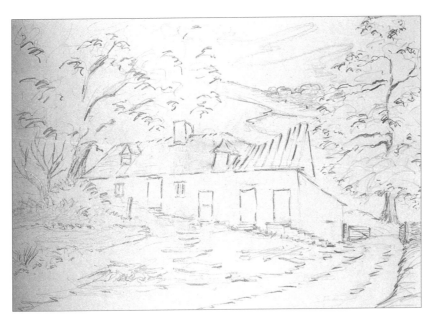

1. The outline plan in soft pencil draws on elements from the individual photographs. Begin to build up the washes on the picture, using horizontal lines for the building and scribbling for the trees.

2. Complete the washes and rub them in well with your finger.

28

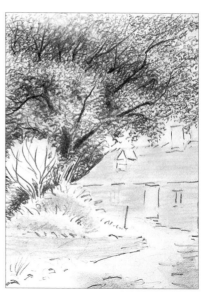

3. Starting at the top left corner, work across the tree, scribbling marks for foliage and putting in highlights and shadows at the same time.

4. Add details of branches to the scribbled-in foliage.

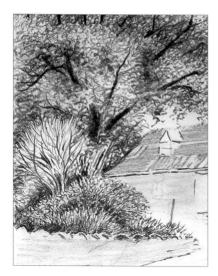

5. Complete the foliage at the base of the tree and begin to plan the position of the rafters.

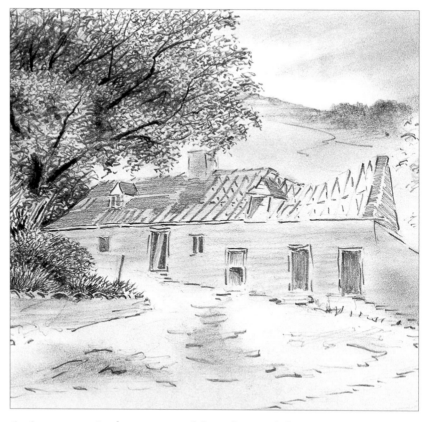

6. Start to put in the position of the rafters and sharpen up the details of the buildings, making any necessary adjustments to the proportions and perspective. Put in a few sketchy details in the foreground.

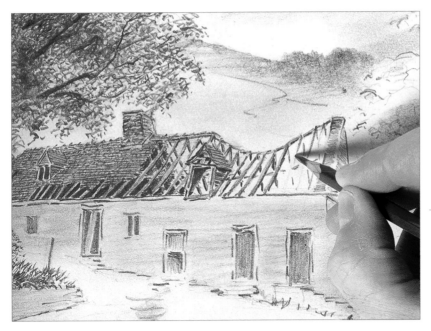

7. Complete the details of the rafters and the sections of roof tile.

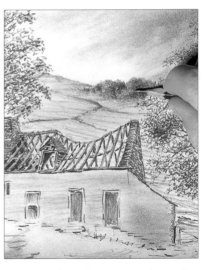

8. Complete the tree on the right using the scribble technique, then accent the clump of trees on the hill to create a highlight on the left of the tree in the foreground. Define the fields.

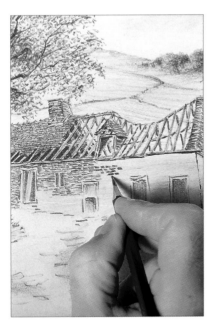

9. Sharpen your pencil to create a chisel point, so you can complete the stonework using one stroke of the pencil for each stone.

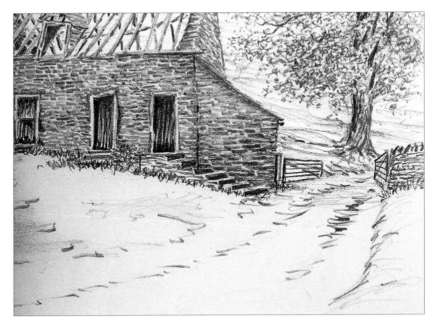

10. Building up a rhythm as you work and still using one stroke of the pencil for each stone, complete the stonework on the building and wall. Sharpen up the detail on the gate and darken the risers on the steps, leaving highlights on the edge of the treads.

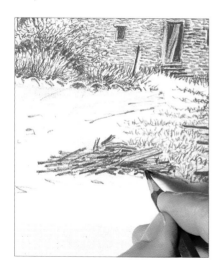

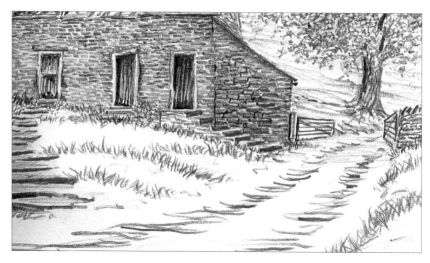

11. Work over your picture and add more fine detail, including the foreground pile of wood.

12. Put in a few lines to describe the contours of the banks and the track. Finish with marks to describe the grass, and horizontal marks of differing tonal values for the track.

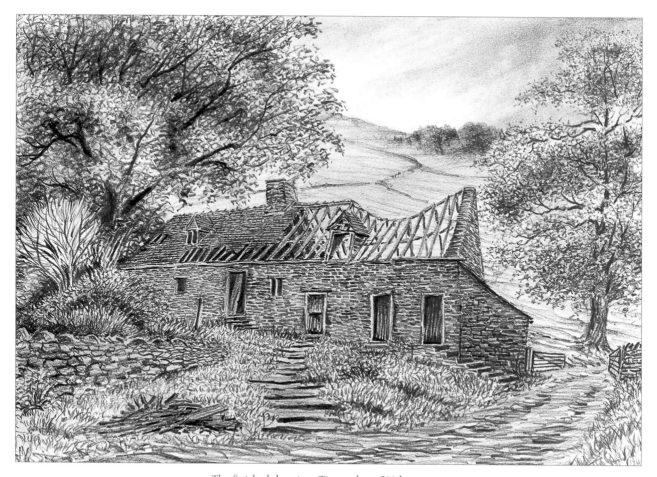

The finished drawing. Time taken: 3½ hours

Trees

Different species of trees have distinctive shapes and patterns of foliage. It is well worth carrying out a series of studies of a wide variety of trees. This will help you to discern the difference in shape and pattern of foliage between, for example, a mature oak, ash, holly or sycamore. Remember that few trees have solid foliage, so look for the shapes of the spaces between the groups of foliage. If you are drawing a tree in winter, make sure you show the overlap of the branches so that the tree will appear to have some depth.

> **Note** *Remember that when you are planning a group of trees, an odd number usually looks best.*

Winter oak

This winter oak is basically round, but slightly one-sided. The trunk is one-third of the total height of the tree, which is true of most trees.

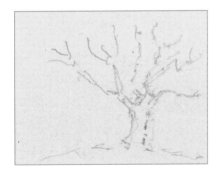

The outline sketch

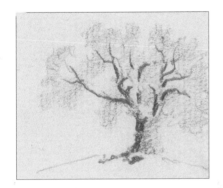

The tonal plan

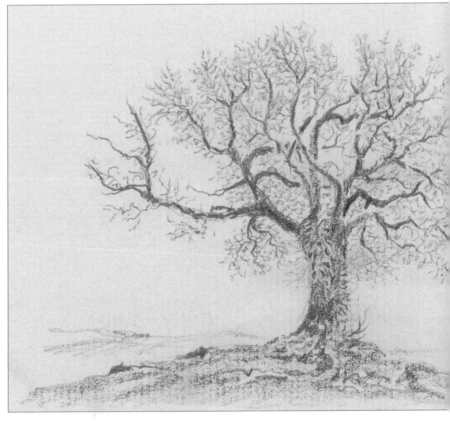

The finished oak

Cedar

The basic shape of this perfectly-formed cedar is triangular, but note
that it is also true of the foliage groups.

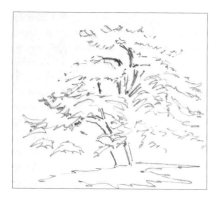

The outline sketch

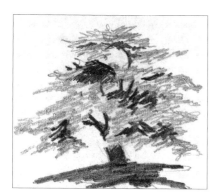

The tonal plan

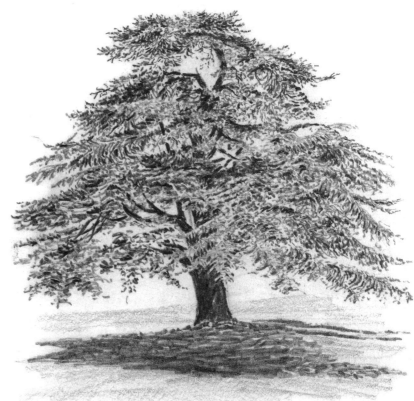

The finished cedar

Copse

In this example, each tree can be seen as a basic shape with a distinctive mark
to record the pattern of each type of foliage.

The outline sketch

The tonal plan

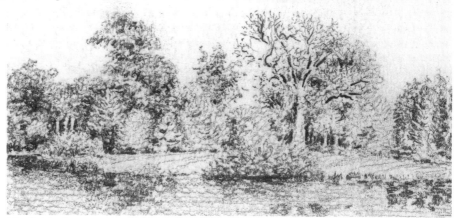

The finished copse

Winter Woodland

Charcoal is a big, blunt and fairly crude medium, and for the best effect you need to work large. A photograph taken in Germany's Black Forest was used as the starting-point. In a composition such as this, where the shadows are so important, the decision about the light source should be made at an early stage. Putting in the very dark and very light areas early helps to give shape to your composition; if you find the contrasts are too stark it is easy to modify them later.

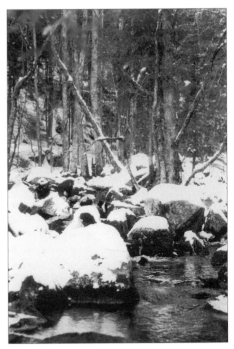

The original photograph

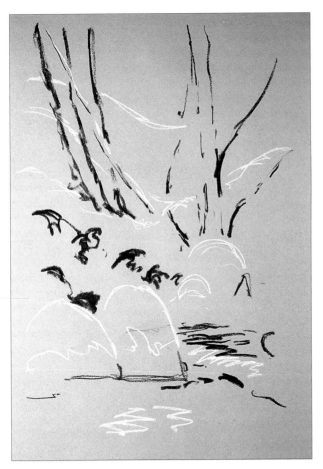

1. With both chalk and charcoal, sketch in a few preliminary planning marks.

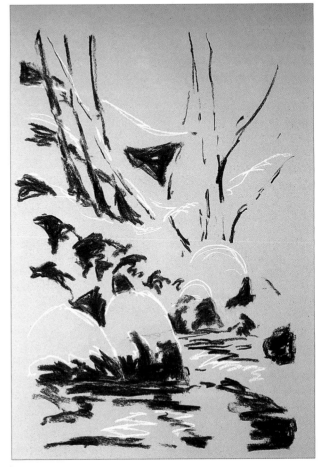

2. Looking at how the composition works from a tonal point of view, block in the very dark areas.

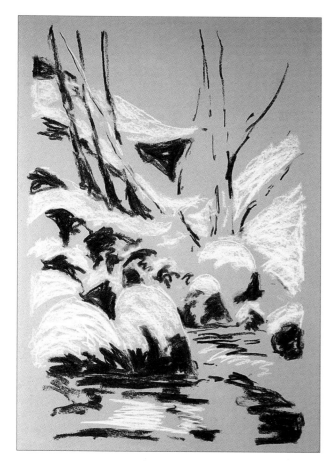

3. In this picture the light is coming diagonally from the top right of the picture. Put in the large areas of white as bold statements, making marks that are sympathetic to the direction of the elements.

4. With chalk, add a small waterfall.

5. Using charcoal held lengthways, work up grey washes to modify the tonal effect of the background.

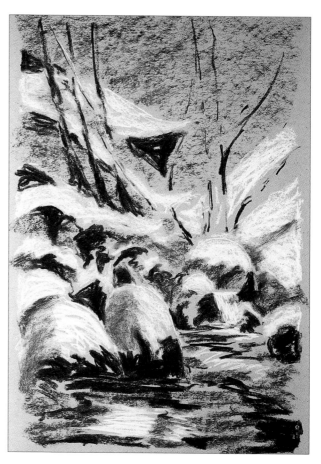

6. Start to add the mid tones, noting the effect of the charcoal over the white chalk of the rock.

35

7. Using charcoal, extend the prominent triangle shape.

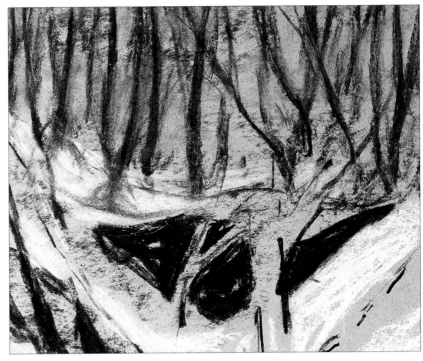

9. Soften the outlines of the tree with chalk to suggest foliage and grey tones.

8. The triangle shape has been extended and passed behind the tree, which has the effect of pulling the tree forward and making it appear to stand out from the background.

10. With charcoal and varying the pressure and angle, add lines to suggest the branches and twigs of the background trees.

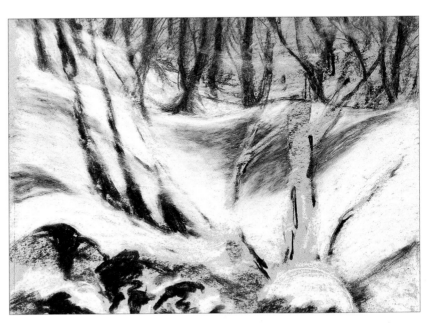

11. With chalk, add snow to the central section, building it up in layers to eliminate the textures of the paper. Use the charcoal held lengthways for the shadow effects.

12. With chalk, harden the edge of the snow drifts.

13. Another design decision: the tree almost in the centre of the picture now looks unbalanced. I have decided to rub the lines out with a putty eraser before redrawing it in a more pleasing shape.

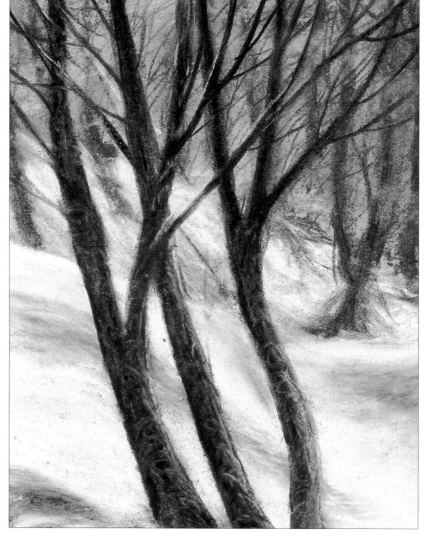

14. With charcoal, draw in the clump of trees in the foreground, then use chalk to add snowy accents to the V-shape made by the branches.

15. With charcoal, sharpen up the definition on the clump of trees in the foreground.

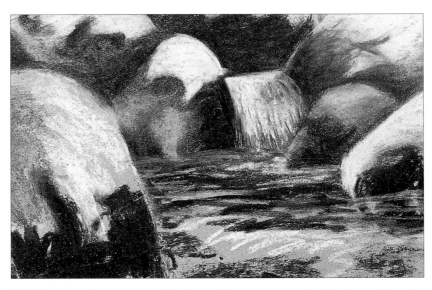

16. With chalk, begin to put texture into the rocks.

17. Sharpen some areas and soften others to create the illusion of depth on a flat surface.

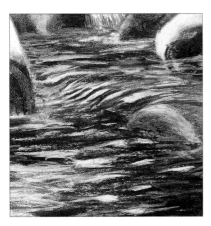

18. Start to work on the area of water, thinking about the tones and reflections as you draw.

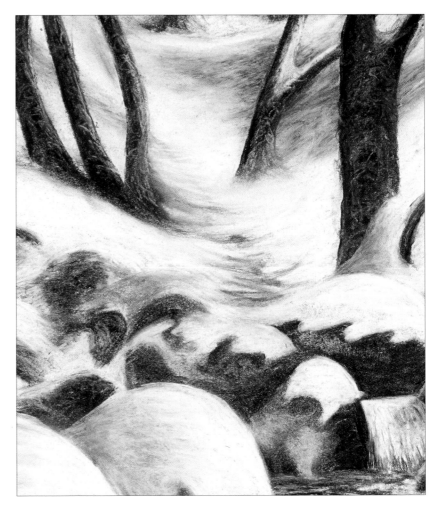

19. When the picture is almost finished work over it with your fingertips using a circular, rubbing movement, to soften the details.

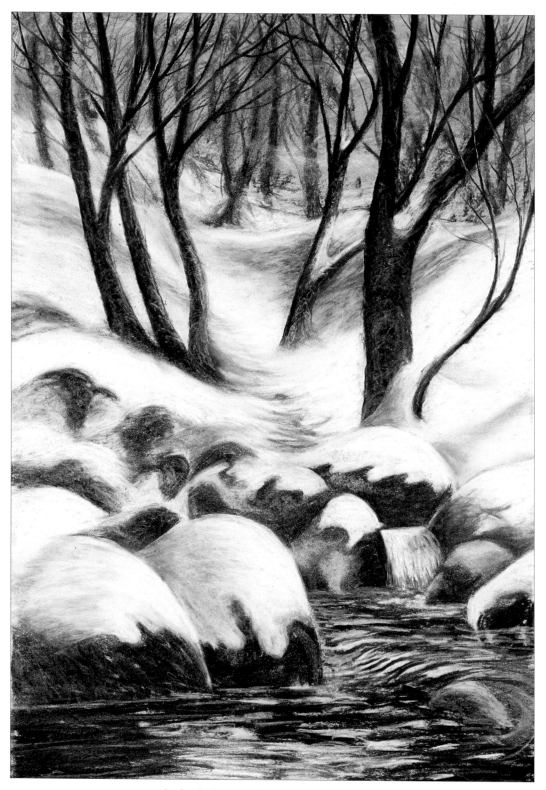

The finished picture. Time taken: 2 hours

Water

The general rule when you are drawing water is that all the marks are fundamentally horizontal because water is flat! It is only when you are working on an area of moving water – as in a close-up of a stream or falling water – that this rule does not apply.

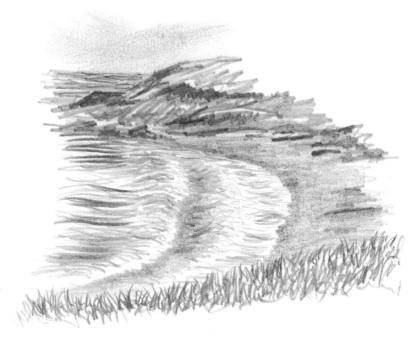

In this beach scene the curved appearance of the waves is created by placing horizontal marks in a curved pattern.

Whatever their size or shape, ripples always have pointed ends.

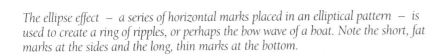

The ellipse effect – a series of horizontal marks placed in an elliptical pattern – is used to create a ring of ripples, or perhaps the bow wave of a boat. Note the short, fat marks at the sides and the long, thin marks at the bottom.

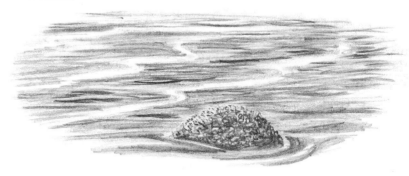

This effect was produced by laying down a wash and smoothing it with my finger, then lifting out the highlights with a putty eraser. Finish by adding a few darker marks to create shadows on the ripples.

When an object protrudes from the surface of still water, the division between the water and the object will be virtually horizontal. If the water is moving, however, there will be a curve or dip to the line.

Reflections

When drawing reflections, remember that the water acts like a mirror so reflections are basically a mirror image. In most cases, reflections are illustrated by making ripple-shaped marks with a darker tonal value, and there is a certain amount of distortion because of the movement of the water.

Where the water is completely still, a different approach is required. In this case, the reflection is drawn with the same marks as the subject to create a perfect mirror image. Horizontal patterns are then lifted out, using a putty eraser, to produce the effect of a surface on the water. In a photograph, or even when you are looking at the scene, these marks may not be there – but if you do not put them in, your work will not look right. This is a good illustration of the fact that what you can accept in a photograph can sometimes look odd in a drawing or painting.

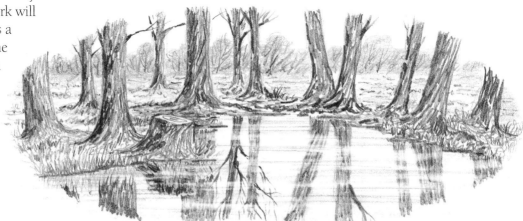

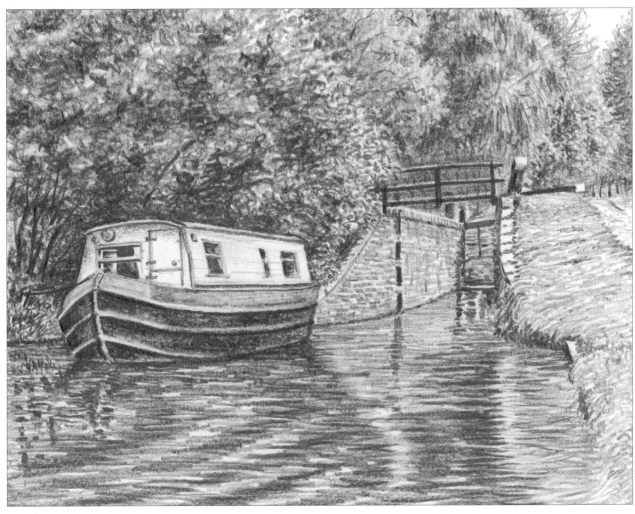

Canal Barge

An important point to remember about reflections is that the marks describing the water are all horizontal. Even if the reflection is travelling diagonally across your drawing, the marks will be horizontal. The tones of reflections usually have a different value from the object, either slightly lighter or darker depending on conditions.

Time taken: 2½ hours

Welsh Waterfall

This waterfall is one of many in a beautiful valley in South Wales. I chose to draw it using coloured pencils because I wanted to capture the warm autumnal tones.

Time taken: 2½ hours

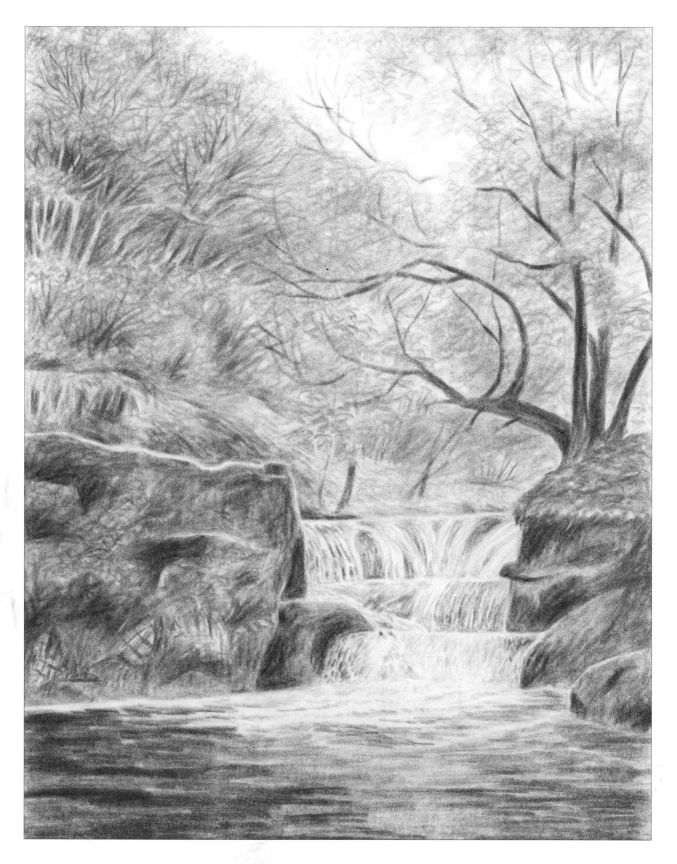

Using photographs

Effective compositions can be produced by drawing on elements from a series of related photographs, if you observe a few simple rules. These mainly relate to the scale of the individual elements. In the examples below, the relative sizes of the girl and the horse can be checked against the stable building which appears in photos A and D. The scale of the gate is drawn from photo C, though the view of the horse and rider is derived from photo B.

As you can also see from the examples below, exposures may vary, so it is also important to take care over the tones and highlights you use in your finished drawing.

Photo A

Photo B

Photo C

Photo D

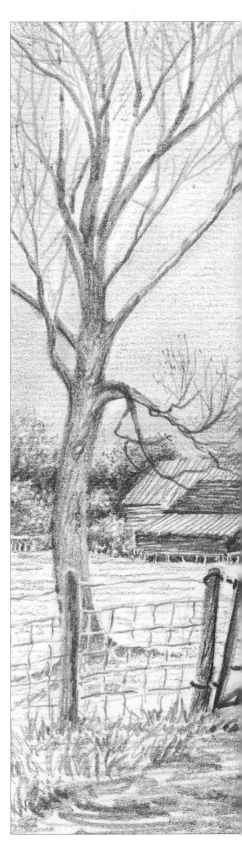

The finished drawing

Going Home

Time taken: 3½ hours

44

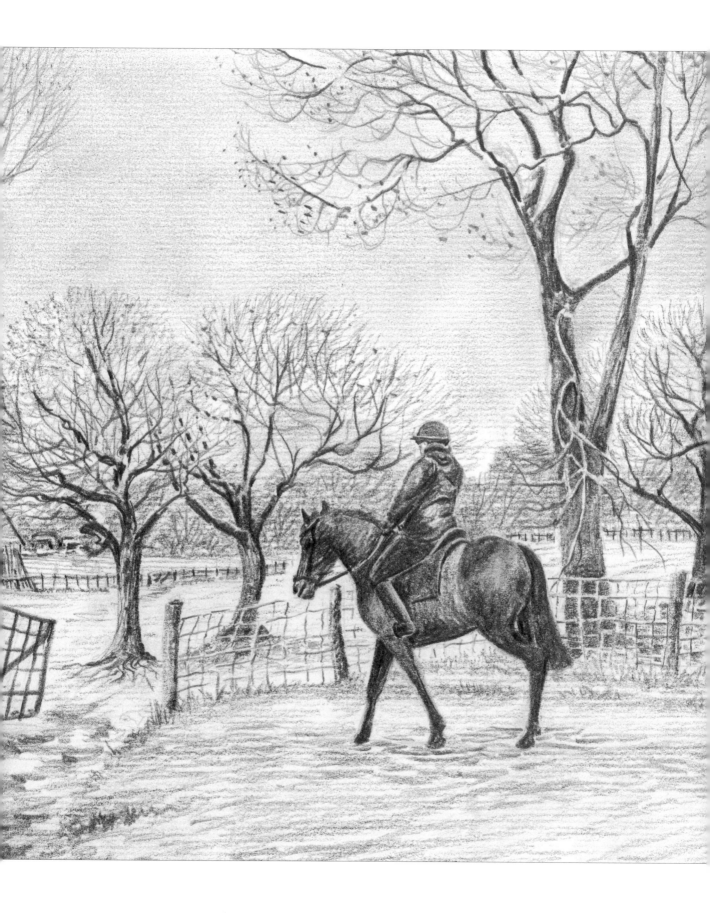

People and animals

People and animals in a picture will always draw the eye. If your picture is intended to be primarily a landscape, take care to make any figures you include very small and inconspicuous. The opposite applies if the people or animals are the reason for your picture; in this case, arrange everything else around them. Most important of all is that you should do one or the other – half-measures will not produce an effective composition.

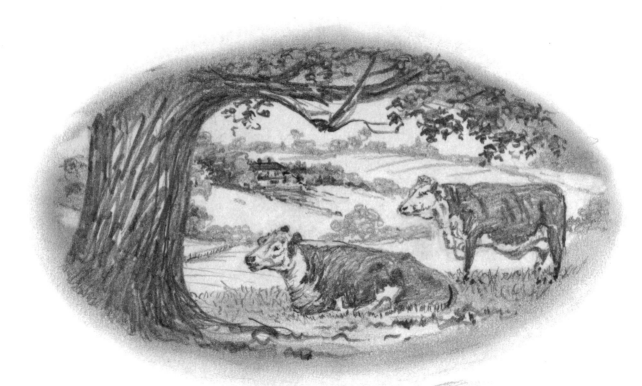

I drew these cattle in the middle of a flat field, but when I came to make a picture I included a large tree to give a sense of scale. The buildings were included to complete the story of these farm animals.

This is a group of horses which are all approximately the same height, standing in a flat field. The scale of the individual horses diminishes as they recede into the distance, but their eyes are all at the same level. Of course, this also works with other types of animals, and people!

Figures in a landscape

Putting a figure in a drawing as a focal point can work well, but I would suggest that you make it a back view to avoid giving the figure a personality – unless, of course, you are including someone you know.

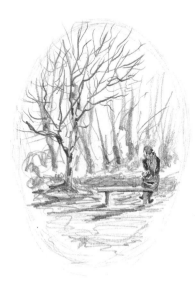

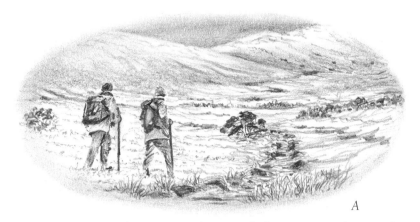

A

An important question when putting in figures is whether you want a drawing of people in a landscape or a landscape with people in it. If it is the latter, ensure that the figures are small enough to be 'discovered' rather than to arrest the eye. Figure A above is a drawing of people in a landscape, while Figure B below is the same view, but is primarily a landscape with people which are almost incidental.

If you decide to have figures in a landscape, try not to put them in the centre of the picture. Here, the figure is on the end of the bench rather than in the middle, and is balanced effectively by the trunk of the tree on the left.

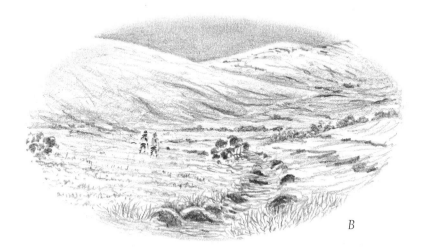

B

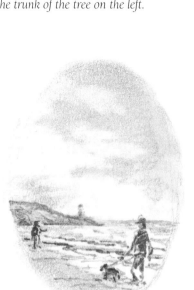

The figure with the dog leads you into the picture, while the figure further away arrests your eye and stops it from running off the picture, which makes the lighthouse the focal point.

Index

Alphabet, drawing 18
Animals 46

Board 9
 coated board 9
 mount board 9, 25

Chair, portable 9
Chalk 8, 34-39, 40, 50
Charcoal 8, 34, 35, 36, 37, 48
Clouds 24-25
Composition 10-11, 13, 18, 19, 34, 44, 46
Contrast 19, 26, 34

Distance 25, 27, 48, 50
Drawing board 9

Easel 9
Eraser 8, 24, 25, 26, 37, 41, 43
Exposures 23, 44
Eye level 14, 15, 46

Figures 47, 48, 49, 50
Focal point 47
Foliage 20, 29, 32-33, 36

Graphite stick 8

Hardboard 9
Highlights 20, 30, 44

Marks, making 18, 19, 20, 35, 40, 41
 Dots 18
 Lines 18
 Squiggles 18
 Washes 18
Masking Tape 9

Negative 18

Paper 9
 cartridge paper 9
 pastel paper 9, 26
 sugar paper 9
 watercolour paper 9

Pencils 8
 chisel pencil 8
 coloured pencils 8, 42
 sharpening pencils 18
 water soluble pencils 8

Perspective 14-17, 18, 19, 29, 31, 50
Photographs 10, 15, 23, 28, 44, 48
Positive 18

Reflections 38, 40, 42

Scribbling 28, 29, 30
Shadows 10, 11, 20, 22, 34
Sketches 13, 19
Sketch pad 9
Skies 24
Snow 25, 36
Stonework 30

Texture 6, 18, 21, 22, 23, 36, 38, 48
Tonal Value 6, 18, 19, 21, 31,41
Trees 22, 26, 30, 32, 34
 cedar 33
 copse 33
 winter oak 32

Vanishing point 14

Washes 18, 20, 21, 24, 25, 28, 35, 41, 48
Water 37, 40-41, 42, 43, 44, 50